An Actor's Guide to Walking the Razor's Edge

D1517515

An Actor's Guide to Walking the Razor's Edge

Michael S. Pieper

Edited by Megan Edwards

Published by Michael S. Pieper
2016

First Printing: 2016

ISBN 978-0-578-17938-4

Michael S. Pieper
2113 N. Springfield Ave
Chicago, IL 60647

Distributed by Lulu.com

Cover picture: Danny Belrose and Sean Marlow in Orpheus Descending by Tennessee Williams at the Trap Door Theater, Chicago, IL 1998

Dedication

To all the actors that I have worked with
on stage and in the classroom,
you have been my inspiration

Contents

Acknowledgement

I would like to thank –
Serge Kahili King, PH.D.
All of the information on Shamanism in this book
Was inspired by his teachings from his books, *Urban Shaman*
and *Huna, Ancient Hawaiian Secrets for Modern Living*

My parents, Bernard and Jean Pieper for all their love
and support!

My niece, Megan Edwards for coming on the journey with me!

Second City for giving me a place to play!

Chapter One

Introduction

You've got the part! This is the one sentence that every actor wants to hear. It puts shivers down your spine. Excitement, joy and a sense of great satisfaction hit you. Eventually, as the actor comes back to earth and starts to think about the character and the world of the play that they will soon enter, a little bit of fear sinks in. Where do I start?

By asking this question, the actor starts to breathe life into the character and starts on a journey of revelation and discovery. There can be many different paths to take on that journey, depending on the circumstances. At the end of the journey, a well-rounded character and performance await. The performance should always be in the back of the actor's mind, but the real focus needs to be on each step to get there. It is this process or craft that the actor develops along the journey that dictates the success of the performance.

> It is good to have an end to journey toward; but it is the journey that matters in the end.
> Ursula K. LeGuin

It is this process that this book will focus on and can serve as a foundation for an actor to build their own process upon.

The motivation behind the process is at the root of the success of it. Why go on this journey? Why act?

Over the years, I've asked this question of actors and have gotten quite the myriad of answers. Examples from actors that are just

starting their careers include: for the applause, for the high it gives me, I like being the center of attention, it enables me to express myself, and I love digging in and figuring out the character. Many of these reasons come and go in importance. They are what motivated myself in the beginning but now just come every so often on this journey.

I have worked with and learned from many great artists and I have seen the heart of what motivates them as artists. It is the exchange of ideas and the responsibility as an artist to make people think and feel. This is the food that feeds the soul of an artist.

Acting is a noble profession needed for our culture to grow and evolve. Many think that it is about escaping and numbing ourselves. That kind of thinking contributes to the decay of our society. Our job as actors/artists is to wake up society. One of my favorite sayings that I have heard from many actors is-*As actors/artists, we are holding the mirror up to society and making it look at itself.* There is nothing more rewarding than knowing you have helped someone to look at them-selves and the world differently and hopefully promoted some kind of positive change.

> Try not to become a success, rather become a man of value.
>
> Albert Einstein

The trick for the actor is not only to feed his soul, but to feed his belly and be able to pay the rent. Finding this balance in show business is not easy. It is a constant struggle and sacrifices on both sides will have to be made at different times.

How do I keep my integrity and not be a sell out? Everyone travels along their own path and the answers will appear when they are sought after. Always remember that the means justifies the end.

Making money and doing what you love doesn't always go hand in hand but it is what most people strive for in the end. This isn't an easy journey at all. It is vital for an actor to be as versatile and multi-skilled as they possibly can to become a working actor. I knew an actor that in one week shot a commercial, posed for a billboard, re-hearsed Hamlet and performed in A Lie of the Mind by Sam Shepard. Each one of these jobs required different skills that he had to develop as part of his process.

Each job and every character the actor creates will have its own unique journey and process. Since the actor is creating a complex multi-leveled human being, it is important for the actor to become a student of the human condition. Not only do they need to examine others, but getting to know themselves is extremely important as well.

It is convenient to break the human being down into parts so that you can learn about each part and its function and motivation. It is a mistake to think that the parts work separately. You can take a rose and break it into parts like the roots, stems, leaves and blossom to study but you must keep in mind that they are part of a whole system of a rose plant and affect each other.

For centuries, man has divided the human being down into different parts to study and understand. Scientists break it down to the cellular level, psychologists study the mind and anthropologists deal

with the origins. What would be the best way for an actor to break down the human condition in order to recreate it?

When I was I my late twenties, I hit a low point in my life. This low point started me on a quest to figure out who I was, what I believed in and where my place in this world was. Shamanism gave me those answers. Shamanism is a form or tradition of healing.

Serge Kahili King in his book Urban Shaman defines a shaman as a healer of relationships: between mind and body, between people, between people and circumstances, between humans and nature, and between matter and spirit. They not only effect people on a personal level but also on social, cultural and environmental levels as well. This is also what actors do when they hold up the mirror to society and get people to think and feel. So it makes sense to break down the human condition and understand it the way that shaman have for centuries. Shaman break it down into three aspects – the basic self, the conscious self and the higher self.

The basic self could also be called the subconscious self. It comprises of the physical and emotional sides of the human condition and their memory. Memory is stored in the body as a vibration of movement patterns. Genetic memory is stored at the cellular level and learned memory is stored at the muscular level. This makes up our body wisdom which is our intuitions, instincts, gut feelings, our hidden drives and abilities. These parts all work involuntary.

The basic self is extremely open to suggestion. In a stressful situation, the person first goes to the genetic memory and if several choices are given it then goes to the learned memory for specifics. For example, maybe there is stress created from difficulty in

> "Two qualities are indispensable: first, an intellect that, even in the darkest hour, retains some glimmerings of the inner light which leads to truth; and second, the courage to follow this faint light wherever it may lead."
> Carl Von Clausewitz

communicating. This might center in your throat and head. Your genetic memory might give you a choice of strep, a cold or nodules. If recently, you have heard that enrollment in a class that you teach is down because of so many students being sick because of colds, this can create stress and may develop in to a cold where you lose your voice.

Many times stress or traumatic situations will block the flow of these memories or create walls around them. Often, in auditions, actors have been so nervous that they forget the name of the play they are doing the monologue from or even worse, forget their own name. The actor should strive to find the triggers that unlock the physical and emotional sides of the human condition to be able to live in the present moment on stage.

The conscious self comprises of the intellectual side of the human condition. Its main function is conscious learning or decision making so that we can better adapt to and think in the world. It decides

where to put the focus. The conscious self decides what is important and want is not and then from that decision the attention follows.

When the conscious self is working in harmony with the basic self it works like a parent with a child guiding, training and inspiring it. When these aren't working together, they become like the parent who pays no attention to the child. This causes alienation between the two selves and we lose touch with our feelings and intuitions. It is imperative for the actor to have a strong understanding of the character working side by side with the physical and emotional parts as well.

> Adventure is not outside man; it is within.
> George Eliot

The Higher Self could be nicknamed the soul. It's comprised of energy which is always inspiring harmony and creativity. The Higher Self ensures that the basic and conscious selves work in harmony. This then helps the whole human condition to be harmonious with the world around it. It is able to live in the present moment tapping into all of its instincts and intuitions. This could also be called the spiritual side of the human condition.

When working together the conscious self generates and directs energy, the basic self memorizes the pattern of the energy and gives you sensations while the higher self uses this pattern to make the experience clear. The actor should strive for all of these to work in harmony so that they can truly live in the moment as the character.

Within these three selves there are four parts of the human condition: the physical, emotional, intellectual and spiritual side. This

method of acting focuses on using tools and skills from these four parts to create a well-rounded character. These four parts will be examined in detail in the following chapters.

The actor should use these tools and skills so that they eventually become part of their muscle memory and are able to let go and live as the character.

This will help them to give strong memorable performances. It is all about being able to get up on a razor's edge; it is so exciting and dangerous that you might fall off and if you are good enough to walk down that razor's edge, it will cut you a little bit. This is because you have to take on this character's pain, joy, frustration or whatever emotion they are feeling.

Chapter Two

A Sense of Play

I lived in many worlds when I was a child. The twenty hay-stacks in my backyard were an immense castle where I held off many enemies. The small cement patch in front of my house would become an Olympic Court where the skate board championship would take place. I was always immersed in this world of play. The older we get, the less we live in these worlds of imagination. It is vital for the actor to develop their imagination and have a sense of play to their work. The actor needs to bring back their childhood skills.

> Without this playing with fantasy no creative work has ever yet come to birth. The debt we owe play is incalculable
>
> Carl Jung

Play has many benefits. Exploratory learning is introduced to us through play. We learn to problem solve with play and it helps our brains with clarity and memory. Play helps to stimulate our creativity and helps us to tap into our instincts and intuitions. Our brains light up when we play and our ability to trust is developed by vocal, facial and gestural play. Lack of play in a person's life can lead to depression. So you can see it is vital to our own health as well.

> You can discover more about a person in an hour of play than in a year of conversation.
>
> Plato

I once worked with a student who as a child was not allowed to play. She had never owned a toy, played a card game or was allowed to take part in games at recess. For fun, her mother would let her read a bible. She had never learned to play. She had all sorts of trouble trying to live in the world of the script and really had problems performing simple exercises that would help her develop her characters. She reminded me that a person really can't act if they don't know how to or won't allow themselves to play.

The journey of creating a character is one of discovery and revelation. There are no right or wrong choices; there are strong and weak choices. The actor should always be striving to make the strongest choice. How are these found? They are found through play.

There are some simple exercises that can foster the actor's sense of play as well as develop other skills. The following exercises also work on an actor's ability to focus, be spontaneous and to use their imagination.

> Only when your consciousness is totally focused on the moment you are in can you receive whatever gift, lesson or delight that moment has to offer.
>
> Barbara De Angelis

State & Color Focus Exercise.

This is an exercise for a group.

1. Have the actors stand in a circle and each actor should pick a different state to say. The first actor says his or her state as they point at another actor. This second actor points at a different actor saying his state and this is repeated till

every actor is pointed at and then it comes back to the first actor. This will always be the person that they point at when they say their state.

2. Then each actor should pick a color and do the same step as #3 but using a color. The first actor then starts with the states and gets it going a couple times and then adds in the color rounds so that you have both the state and colors going at the same time. Remember that they always point to the same two people, one for their state and one for their color.

The Trust Exercise

This is done with actors in pairs.

1. Actor one closes their eyes as actor two leads them around a room or building, making sure that actor one does not hit anything.
2. After 5 minutes have actor two let go of actor one and only talk him around the room.
3. After 5 minutes the actors should switch and perform steps #1 and #2 again.

The Four Elements Exercise

This is to be performed with a group.
1. The group stands in a circle with one actor in the middle holding a ball.
2. The actor with the ball throws the ball to an actor in the circle saying either earth, water, air or fire.
3. The actor that the ball is thrown to must catch it and throw it back immediately answering at the same time. The answer depends upon what element is said to them by the middle actor. For earth, they must say a type of animal, a type of fish for water, a type of bird for air and they must turn around twice and scream when fire is said.

4. If the actor in the outer circle does not reply immediately with the appropriate answer, they have to then take the place of the actor in the middle. Answers can never be repeated.

> Only in spontaneity can we be who we truly are.
> John McLaughlin

Storytelling Exercises

These are to be performed with a group.

Long Story Form

1. The group should stand in a circle with the instructor in the middle.
2. One actor starts to tell a story.
3. When the instructor points at another actor in the circle that actor continues the story. The instructor should randomly point at different actors keeping the actors on their toes and thinking quickly.

Word Building Story

1. The group should stand in a circle.
2. One actor is picked to start and says the first word of the story.
3. Going clockwise each actor should add a word to slowly build a story.
4. This can go around many times until a complete story is told.

Animal Triple Play Exercise

This is to be performed in a group.

1. The group stands in a circle with one actor in the middle .The actor in the middle points at an actor in the outer circle saying either monkey, elephant or eagle.
2. If a monkey is said then the person pointed to must put their hands over their eyes, the actor to the right of that actor puts his hand over their ears and the actor to the left of that actor puts their hand over their mouth. For an

elephant, the right and left actors become the ears of the elephant with their arms and the middle actor becomes the trunk with his arms. Lastly for an eagle, the left and right actors become the wings and the middle actor becomes the beak.

3. If any actor does not perform the correct physical activity, they have to take the place of the actor in the middle. This all should be performed quickly.

I highly recommend studying improvisation. The benefits to acquiring the techniques and skills of improvisation are numerous. Improvisation helps you to become spontaneous, to live in the present moment and to tap into your instincts and intuitions. It can help you create memories for the character or emotionally charge you for a scene. Most importantly it gets you to play.

When the actor is in rehearsal, they should not be afraid to lose their inhibitions and try different choices. You never know what will be discovered. Even if what you discovered doesn't work, you then can get on to what does work. Go the distance and experience the different choices. You can always pull back and refine your choices and discoveries. Directors love actors that bring different choices to the creative table. It is always easier to pull back than to have to push the actor forward.

I once worked with an actor in a production of Ten Tiny Fingers, Nine Tiny Toes by Caryl Churchill. He was playing a character that was a member of the society's lowest class. He was uneducated and animalistic. The actor didn't know how stupid to make him and was having trouble getting into the physical side of the character. So

one rehearsal he came in and tried the character extremely slow and mentally challenged. It certainly was too extreme but out of it he found the inner tempo of the character and the way the character physically moved. He would have never found these qualities if he didn't play and allowed himself to the chance fail.

All of the exercises and tools in this book are designed for the actor to play with and find the strongest choices. Stay positive, don't be afraid to fail, and allow yourself to play so that you can experience joy in your creative process.

Chapter 3

The Conscious Self

The conscious self is the intellectual side of the human condition. It plays the main role in focus and decision making. The intellectual side makes sure that there is understanding in the communication process. Without understanding, there is no hope for effective communication. Before the actor can create a character, they first need to have an understanding of the character and the world of the play.

The first step of the intellectual side in the process of creating a character has to start with the script. The actor first has to understand the world of the play so that they make appropriate choices in regards to the character and their background.

Go to the script. Read it two or three times and then it is time to analyze it.

> "Any fool can know. The point is to understand."
> Albert Einstein

The best tool to use in analyzing a script is to use Aristotle's six elements to a play. Although he developed this tool centuries ago in his book the Poetics, it still is effective today. The six elements are:

1. PLOT – what happens in a play; the order of events; the story as opposed to the theme; what happens rather than what it means. Try to put the plot into one short

sentence. For instance, boy falls in love with girl and his cheating destroys the relationship. If it is easy to put into a sentence, it is character driven. If it is difficult, then it is plot driven. Also try to put the plot into the well-made play structure. These are the elements:

a. Exposition- all of the history and background of the characters.
b. Inciting incident- the moment when you first realize there is some kind of conflict.
c. Climax- the moment of highest tension.
d. Crisis moment- the moment that leads to the climax happening. Before the crisis moment many different climaxes could happen but because of the crisis moment, it leads to that particular climax happening.
e. Falling Action- the wrapping up of the story.

In Eugene O'Neill's Desire Under the Elms, the exposition is revealed by all of the character throughout the first act. The inciting incident is in the first scene when Eben says the he wishes his father was dead. The climax is when Abbie kills the baby. The crisis moment is when Cabot tells Eben that Abbie has been lying to him the whole time and the falling action is all of the action after the baby is killed.

2. CHARACTER – the personality or the part an actor represents in a play; a role played by an actor in a play. The easiest way to do this is to use the 6 Levels of Characterization. With each level go to the script and see what information the playwright gives you. The 6 Levels of Characterization are:

A. Physical: Go to the script and see what the playwright says about the character physically. Look at what both the character and other

characters say about the physical appearance and then determine if the actor needs to adhere to these physical traits. Sometimes it does matter, as in the case of John Wilkes Boothe in the musical Assassins because he is a historical figure and most people have a vague idea of what he looked like when he was alive.

B. Classification: How does the playwright, the character and other characters classify this character? Student, friend, loving, charming, manipulative, seductive, naïve, courageous and dirty are all ways to classify or stereotype the characters.

C. Habits: What are the character's verbal, physical, emotional and intellectual habits? For instance, verbally do they repeat words or phrases? Physically, do they have certain gestures or self-adapters? Self-adapters are learned behaviors that we develop to handle certain emotions. For instance, when we are nervous we bite our fingernails. Emotionally, do they avoid certain emotions or are addicted to others. Intellectually, do they use reason and logic to protect themselves?

D. Goals and Desires: What is the character's goal? The goal is long term. Try to sum it up with an active verb. In Eugene O'Neill's Desire Under the Elms, all of the characters' goals are to possess the farm. Desires are more short term like Abbie in Desire Under the Elms wanting to seduce her stepson.

E. Choices and Decisions: What are the choices and decisions that the character makes to get their

Goals and Desires? Abbie decides to lie to her
husband and makes him believe that the baby is
his and his son's child.

F. Moral Choice: What are the values and morals
of the character? Abbie is lacking values and morals
because she sleeps with her stepson and in the end kills
their child to try to keep her stepson's love. She has
strayed from the puritanical religious background of the
characters.

3. DICTION/LANGUAGE/DIALOGUE – the word
choices made by the playwright and the enunciation of
the actors delivering the lines. Is the script written in
acts or scenes? Is it written in poetry form or in quick
back and forth dialogue? Maybe it is in longer
passages and the playwright uses a lot of metaphors
and imagery. There may be slang from that time period
or the dialect is written in the dialogue.

4. THEME – what the play means as opposed to what
happens (plot); the main idea within the play.
Sometimes the theme is in the dialogue or title like
You Can't Take It With You. Other times it may not
be as apparent or the script can have many themes.
Eugene O'Neill's Desire Under the Elm's theme could
be that greed can destroy you. All of the characters'
greed in that play lead to their tragic downfall.

5. MUSIC/RHYTHM – by music Aristotle meant the
sound, rhythm and melody of the speeches. Listen to
all of the aural aspects of the production, as well as the
actual songs and the sounds in the background. There
are rhythms and a melody to Eugene O'Neill's Desire
Under the Elms, because he writes the accent into the
words and dialogue. The accent is part a New England
Dialect and part his own creation. Once the language

is mastered it has a beautiful and unique melody. Also many scenes take place outside and sounds of birds, crickets or the wind could contribute to the atmosphere.

6. SPECTACLE – the visual elements of the production of a play; the scenery, costumes, lights, props and special effects in a production. Some playwrights are extremely specific about these elements and others leave it more up to each production. Whichever way they go, I believe that they need to support the theme and serve the play.

I always like to think of myself entering this new world of the play. What do I need to know about it so that I won't be an alien but become a resident in that world? These six elements of Aristotle's help you to start asking questions. Become an investigator of that world and your character. It is not about finding the right answers but about asking the right questions to get those answers.

The next step on the intellectual side is to develop the beat work. Once you understand the world of the play you'll want to start to get up as the character and live in that world. You need to think, feel and react as this new character. Without beat work, this can be extremely difficult. You might be in and out of thinking as the character or become aware of the audience and overly conscious of yourself. The beat work can serve as a road map for the journey of the character. I have seen it time and time again, actors not using beat work and then they seem lost on stage and their performances are inconsistent.

Every moment you are wanting something, either consciously or subconsciously. Most of the time you are wanting something subconsciously because you aren't aware of what you want. Our mind is always working. Even when we are trying to do nothing, there is still purpose in each moment. That means that you need to figure this out for each moment that the character lives on stage. This means breaking the script down into beats.

A beat is a psychological unit of time where a character plays an objective. If the character gets what they want or starts playing a new want there is a beat change.

There are six parts to a beat:

1. The object – The person or thing you are talking to. It is usually one of three things – another character, yourself or God. Even if it says in the script that you are talking to the audience, I treat the audience as another character.

2. The given circumstances– The character's biography, the play's historical, economic, political and religious background. Everything you know about yourself, you should know about the character and more. It is the who, what, when, where and why questions. The given circumstances make up the world of the script. The more specific you are, the easier it will be to live in that world. Ask yourself what you need to know to go from being a tourist in that world to becoming a native in that world.

3. The objective – What the character wants. You want to get it down to an active verb.

4. The obstacle – What is in the way of the character's want? It can either be the other character's want or something

inside your character. This can be stated in a phrase or sentence.

5. The physical - How do you carry out this objective physically?

6. Emotional transition – this is the moment between beats. What in the first beat is triggering your character to play the next beat? It can be the other character or something that you say near the end of your beat.

By breaking down the script into beats and identifying the six parts of the beat, you'll create a road map of the character's journey. This process helps you to get extremely specific with each moment of the character's life.

The first part of the beat to identify is the object your character is talking to. In the dialogue beat work example on page 28, Bill's object in the first beat is his wife Jill. In fact, Jill is his object in all of his beats except for beat 7 where his object is himself.

You would then identify the given circumstances. I usually will develop the given circumstances before I even start to do the beat work. That way when I do the beat work, I can pick out quickly the circumstances that affect that beat. Everything you know about yourself and the world that you live in, you need to know about the character. You're actually going to know more about the character than they know about themselves. My character might not know that they have post-traumatic stress syndrome but you the actor need to know it so that you can put it

in the character's behavior. Go to the script first and get as much information as you can then, based on that information, make up the rest. Be specific. The given circumstances dictate what a character wants and then how they react in the moment. The more specific you are with the given circumstances, the easier it is to live in the world of the play. The following list of questions will help you to start to develop the given circumstances.

Given Circumstance Questions
Where was I born and raised?
How big is my family?
What is my birth order in my family?
What is my education?
Do I believe in God?
What is my religion?
What does my father do for a living?
Mother?
Economic status?
What was my favorite subject in school?
I am ashamed of…
If I were an animal I would be...
Where do I live?
What is going on politically?
What do I do to make money?
What has been a tragedy in my life?
What has been my greatest accomplishments?
How do I treat people?
What are my most important relationships?
What are my eating habits?
What do I do for fun?
The thing that made me cry the hardest was...
My favorite type of music is…
Do I smoke?
Drink?
Do I talk too much?

Do I try to keep up with fashion?
Am I concerned with how people perceive me?
My country is...
Family history?
Relationship to mother?
Relationship to father?
I cannot stand people who...
Have I ever been in love? If so, when?
What is my emotional state now? Before?
What scares me?
What jobs have I had?
Do I have kids and what is my relationship to them?
Do I like to be touched by people?
Do I think I'm right most of the time?
Do I think that I am better than some people?
Do I blow things out of context?
People like me because...
Do I exercise?
How do I handle conflict?
What is the state of my health?

Another part of developing the given circumstances is to create the memories of the character. The memories are what trigger our basic self. They are what help us to feel authentic emotions. This process is described more in the emotional section of this book. When I talk about a car accident, the images and the memories are played in my mind. So

> Memory is the diary that we all carry about with us.
> Oscar Wilde

for example, if your character is talking to a friend about the fight he had with his father, you need to create the memories and images of that fight so that the character can be thinking of these images and memories when he is talking. Visualizations will help you to create these memories. Visualization is to recall or form mental images or pictures.

Visualization is much like meditating. You sit with your eyes closed and in your mind visualize the experience. Try to be as specific as possible with the details of the memory. Once you have done the visualization, then you can use the images and pictures that you created. This will then help you to start thinking as the character and letting these memories affect you emotionally.

The given circumstances that are given in the dialogue beat work example on page 28 are that they have been married for 5 years and that they don't have children. You also get a sense that she has done this before. If this was from a full length play, I would then go to the rest of the script and try to answer the rest of the given circumstance questions. I would then make up the rest of the information based on what I got from the script as well as create some visualizations of the memories when she was drunk. Some of these memories might be when she embarrassed him in front of his friends, when she crashed her car or when she passed out at a formal party. All of these images will be triggered as he is going through the scene. Developing the given circumstances specifically is one of the most important steps when developing a well-rounded, complex character.

The third part of the beat is to identify your character's objective. What they want. Get it down to an active verb. Your character may want to get revenge on his girlfriend because she cheated on him. You can't play a noun like revenge but you can play *to hurt* her or *to torture* her and these wants will help you to get revenge. Always state

the want with a to before the verb. Don't put a be in the phrase because that makes it inactive.

It is hard to play a want like *I want to be drunk*. You can play *to numb* yourself or *to escape* reality. Active verbs work the best. Find the strongest choice that connects you to the character. Stay away from weak choices like *to tell*, *to show* or even *to explain*. There is no right or wrong to finding an objective or your active verb, there are only strong and weak choices. The following list of verbs will help you to find the strongest choice.

Strong Active Verbs

Destroy, consume, obliterate, ruin, shatter, convince, tease, allure, charm, string along, annoy, badger, bait, hurt, bruise, mangle, mar, mock, belittle, flaunt, assure, impel, induce, influence, inspire, instigate, motivate, persuade, pressure, prompt, stir, sway, talk into, win over, enlighten, shell, bombard, blitz, seduce, scorn, confess, corrupt, defile, demoralize, pervert, ruin, taint, arouse, lure, deflower, awaken, arouse, excite, annihilate, destroy, shatter, devastate, dismantle, butcher, crush, extinguish, suppress, pulverize, demolish. suppress, subject, confine, prevent, smother, suffocate, conquer, crush, dominate, enslave, silence, choke, boost, crush, pulverize, defeat, drown, overpower, overwhelm, squash, trample, help, baby, pamper, nurse, amend, arouse, assist, promote, spur on, inspire, agitate, anger, propel, provoke, encourage, electrify, spark, stimulate, turn on, assure, pressure, touch, instill, instruct, egg on, boost, incite, induce, amplify, attract, delight, inflame, tempt, overwhelm, lavish, amaze, astonish, awe,

astound, delight, wow, electrify, horrify, outrage, belittle, cheapen, defile, deflate, degrade, mortify, blast, condemn, vilify, overrun, brighten, enliven, reassure, strengthen, hamper, ignite, activate, energize, kindle, nourish

The length of a beat is determined by how long your character plays the objective. It may be for a sound to half of a page of a script. Each beat has only one objective or want. If you start playing a new objective, then that is a new beat.

The objective of the first beat in the dialogue beat work example on page 28 is *to test.* To find the objective and make sure it's the strongest one in the beat, the actor should get up and try several different choices. Other choices you could have tried in the example is *to trick* or *to tease.* *To test* ended up being the objective that felt the strongest. Make sure that when you are working on the objectives, you are getting up and trying the different choices. Don't be afraid to play and try different choices. That is the only way you will find the strongest choice.

The obstacle is the fourth part of the beat to identify. It is what is in the way of what your character is wanting. It can be either what the other character wants or something inside yourself. The obstacle can be stated in a phrase or sentence.

In the first beat of the dialogue beat work example, Bill's obstacle is his fear of her answer. In beat 5, his obstacle is Jill wanting to manipulate him. Every beat has a want going up against an obstacle. It is that want going up against the obstacle that creates a thought that taps

into a memory. The result being an emotion. Note that if you start playing a new objective and have a beat change, the obstacle doesn't have to change. The character might be trying a new objective to get past the same obstacle.

The fourth part of the beat to identify is the character's physical make up. How does the objective manifest itself physically? It might be as simple as digging your thumb into your finger. In the dialogue example in beat 2, Bill may be throwing the bottle at Jill as he plays the objective *to hurt* her. Many times the physical is manifested naturally or involuntarily. Other times because of the given circumstances, it has to be created. Your hands may go naturally into a fist when you want to hurt someone but throwing the bottle will make the scene more exciting and dramatic. The physical side of the human condition will be explored more later on in this book and will help you in making these physical choices.

The emotional transition is the sixth part of the beat to identify. Think of these transitions as the ligaments that hold the beats together. These emotional transitions are the moments in between beats. You always want a forward movement to your beat work. This moment is triggering the next moment. Even if the character is dealing with the past, the past is propelling them forward. What in this beat is triggering you to play the next objective? It might be triggered by one of two things:

1. It could be something that the other character says or does. In the dialogue beat work example, Bill is triggered to want to hurt Jill

when she says the word *never* to him. He starts playing the objective even before he speaks. This is why beat changes can happen in the middle of sentences or even in the middle of words.

2. The trigger could be in something that the character says himself. In beat 7 of the dialogue beat work example when Bill says children, it triggers him to think of her as a mother plus maybe she couldn't get pregnant and he blames her for that so he wants to hurt her.

Transition work can help you flush out the given circumstances and help you to think as the character. Transitions happen instantly. Try to stay away from indicating them.

Transitions can also point out silent beats. A character might say "I hate you, I'm sorry." These would be two beats- *to hurt* and then *to apologize*. This would come off psychotic if those two were played next to each other. To make it more natural, you would have two silent beats in between *to hurt* and *to apologize*. These objectives might be *to control* myself and then *to calm* myself. You would first play *to hurt* by saying the line "I hate you". Then, you would have the silent beat *to control* yourself and then *to calm* yourself. Then, you would need to say "I'm sorry" *to apologize.*

Most of the time we play the transitions naturally but when a character gets more complex it helps to be able to identify the transitional triggers. Eventually, when you get good at playing objectives, there will be a little bit of residue from the last beat in the beginning of the next beat because that is what triggered it.

The beat work is a tool that helps you to become more of an artistic collaborator and enables you to give the director different choices. It's what you figure out on your own and then go to rehearsal and try. You learn it to forget it. You can't be in the moment as the character thinking I want to hurt you despite the fact that I love you. You play with this at home and get the feeling, then you go to rehearsal and in the moment of the scene you need to be thinking as the character as you're acting out the beats. The beat work needs to become part of your muscle memory.

The piano player learns each note and then discovers the relationships and harmony between the notes. Eventually, after much practice, the piano player doesn't think about the notes and starts to feel the music. They become one with the music and then the soul of the song is found. The actor's process is much like that of the piano players. The actor and the character become one and the soul of the character rises.

Dialogue Beat Work Example

Bob 1/Are you hiding something?

Jill What are you talking about? I would never 2/keep anything from you.

Bob You're lying! 3/ I found this empty vodka bottle with your lipstick on it.

Jill Ok, I started drinking again. You drove me to it!

Bob 4/I what? 5/ I am not going to play this game again.6/Your drinking has destroyed our marriage. It has been 5 years

of hell! 7/ Thank God we never had children! 8/ Drunks make horrible mothers.

Jill I am not a drunk! I just want life to be a party!

Bob 9/This party is over!

Objectives are in **bold** and the obstacles are underlined below.

1. I want **to test** my wife despite my fear of the answer.

2. I want **to hurt** my wife despite my love for her

3. I want **to prove** her guilt despite her denial.

4. I want **to understand** her despite her insanity.

5. I want **to protect** myself despite my love for her.

6. I want **to destroy** her despite my love for her.

7. I want **to reassure** myself despite my want to have children.

8. I want **to hurt** her despite my love for her.

9. I want **to escape** this marriage despite my commitment to it.

Exploring language

Analyzing the dialogue and language can help you to better understand and connect with the character. The actor builds their performance from the words the playwright has given them. It is vital for the actor to build a relationship and use the words. The annoying exercise can be the first step in building this relationship.

> Words have power. Words can light fires in the minds of men. Words can wring tears from the hardest hearts.
> Patrick Rothfuss

The Annoying Exercise:

Have your partner stand about 3 feet away from you. Start saying your lines. Your partner should interrupt you and make you repeat your nouns, verbs, adjectives and adverbs. This will help you to bring out your words and taste them more. For example, your line is *Joan ran stupidly from the scary robber*. The partner may interrupt and ask, "Who ran?" Joan. "How did she run?" Stupidly. "Who did she run from?" The scary robber. "What kind of robber?" Scary. The partner is not helping the actor saying the script if they let them get through a whole sentence without interrupting them at least 3 or 4 times.

Crafting the Dialogue

The following eight tools will help to solidify your relationship with the language.

1. Telegram. Telegram is highlighting of words so that the actor will employ proper word selection. The nouns and verbs in each sentence of the dialogue should be underlined. Pronouns should not be underlined unless they are used in comparison. The actor then brings out these words in order to tell the story more clearly, as well as these are the words you use to play your objective. The adjectives and adverbs should have a squiggly line underneath them. These words are also to be brought out in order to enhance the story. For example: A *small* man came to the house of Death and the *uniformed* guard at the gate asked him what he wanted.

30

2. Caesura. A caesura is a small break in the action which pushes the action forward. It is used to highlight words and break up lists. It is marked with a check mark with a squiggly tail. For example: A small man came to the house of ^Death and the^uniformed guard at the gate asked him what he wanted.

3. Endings. There are three different ways to end a sentence. These are: up, down and neutral. They are marked with arrows which coincide with the word. Most of the time the actor should use up or neutral endings to keep the energy of the words flowing. The only time an actor should use a down ending is when they are finishing a point. Getting into a down ending habit can be detrimental to an actor's performance and can stop the energy from flowing.

4. Denotation. It is the literal or primary meaning of the word. Look up the definitions of the important words of your dialogue. We take for granted that we know the meaning of words and many times the playwright will play with the deeper meaning or the double meaning of the word. You might think the word gone means left but it has a deeper meaning of lost, ruined and dead. This gives a much deeper meaning to the statement: *I was gone so he found another*. Also words had different meanings in the past. When Juliet says "Romeo, Romeo Wherefore art thy Romeo", most people think she is asking where he is. Wherefore meant why back in Shakespeare's time, so she is actually asking Romeo why he is a Montague, an enemy of her family.

5. Connotation. It is a feeling that a word invokes. Words many times sound the way they feel. For instance, the word *hard* has that feeling of hardness when you say it. Compare that to *heart* which has a soft, vulnerable feeling. *Home* makes you feel safe, warm and comfortable. Get up and walk around the room as you take each important word in your dialogue and repeat it until it makes you feel something and get it in your body. In the statement, *His confession was a brutal lie,* you would repeat confession, brutal and lie. This can seem very tedious but you will see a huge difference in your emotional connection to the words.

6. Origin of the Idea. Where does this idea originate in the experience of the character and where does it originate in the body of the character? Heavenly says in Tennessee William's Sweet Bird of Youth, "Don't give me your Voice of God speech." She has experienced this speech over and over again. She has heard it at her father's political rallies, at the dinner table and any time he feels threatened. It probably makes her feel sick to her stomach, so it originates in her stomach. Once you have found the origins of the experience and the place in the body, get the feeling down to verbal garbage and let the sound originate from that body part. Blaahhh might be the verbal garbage that helps you to connect to the origins. Go through this process with each thought or idea that the character says. This helps you to own the language and flush out more of the given circumstances.

7. Syntax. It is the arrangement of words and phrases to create sentences. This creates tone, mood, rhythm and atmosphere. Note how the playwright uses punctuation and their arrangement of words. If your line is: *I feel cold, dry, empty*, the playwright doesn't want you to rush through it but to feel each one of those adjectives. The sentence may be extremely long with no commas, which means the character's mind is racing and you need to say the sentence fast to get it all in one breath.

8. Personalization of the Dialogue. This has four steps and will help you to connect with phrases that are more poetic or unfamiliar to you.

1. Say the line. Example: *Don't give me your Voice of God Speech!*

2. Put the line into your own language. Example: *Shut up!*

3. Find a memory that is similar to that of the character and try to get the feeling back. Example: I remember when I was a teenager when my father was mad at me and I told him to shut up.

4. Put the line back into the language of the playwright and say the line with that feeling.

If the line is the way that you would say it, then you don't need to personalize it. This tool can help you with any classical and contemporary scripts that are more poetic and contain elevated language.

Remember crafting the dialogue is to build a better relationship to the language and it contains many clues to connecting to the character. Don't let these tools lead you down the thought process of how to say the line. It is why you are saying the line that dictates the way that you say it.

Chapter 4

The Basic Self

The main function of the basic self is physical and emotional memory. There are two types of memory: 1) genetic memory, stored at the cellular level and 2) learned memory, stored at the muscular level. Memory is contained in the body by vibrations or movement patterns which make up our subconscious. Genetic memory comes from our ancestors and is given to us through our DNA and is in every cell. Learned memory comes from our experiences and is stored in different parts of our body depending on which part of the body is active during those experiences.

The actor needs to develop tools to tap into the physical and emotional memory therefore being able to work from the subconscious. When we work from the subconscious, we can utilize our instincts and intuitions.

> Life is all memory, except for the one present moment that goes by you so quickly you hardly catch it going.
> Tennessee Williams

Physical Memory

Tension in the parts of the body where the memory is stored can inhibit releasing that memory. For example, when we are hurrying to leave the house and can't remember where we put down our keys. You might be late for an appointment and are stressed out.

This might be creating tension in the part of the body where this memory is stored. Many times by calming down and relaxing, the memory will surface.

This is why it is extremely important for the actor to start his work in a neutral relaxed state. It is like a painter starting with a clean, blank canvas. Before every rehearsal and performance, the actor needs to get rid of their own tension and then build upon the character's basic self.

Just like an athlete, the actor needs to do a complete warm-up.

The following exercise is a simple warm-up which can serve as a foundation for any actor to build upon.

Basic Physical Warm-up

1. Stand with your feet comfortably under your body, supporting your weight evenly.
2. Imagine a string being pulled from your pelvis up through your torso, neck and head like a puppet. This enables you to stand up straight.
3. Stretch your right arm up to the ceiling. Hold for a count of ten. Lower
4. Stretch your left arm up to the ceiling. Hold for a count of ten. Lower.
5. Stretch both arms to the ceiling and again, hold for ten.
6. Bend at the waist and stretch your arms parallel to the floor out forward. Hold for a count of ten.
7. Let your arms hang to the floor and bend your knees slightly, stretching the lower back. Take a deep breath in and release it. Repeat the breath again. Think of all the tension dripping out of your fingertips to the floor.
8. Slowly roll back up vertebrae by vertebrae, with the head being the last to come up.
9. Roll your head slowly, making sure you are pulling up and that your mouth hangs loosely. You want to stretch your muscles and not grate your vertebrae together. Roll ten times one way and then ten times the opposite way.

10. Roll both shoulders forward ten times and then the opposite way ten times and then roll them opposite of each other ten times.
11. Slowly roll over from the shoulders bending at the waist and bring your hands to the floor. Bend your knees and bring them to the floor so that you are supporting your weight on your knees and hands.
12. Arch your back to the ceiling for a count of ten.
13. Arch your back the opposite direction for a count of ten. Repeat 11 and 12.
14. Slowly sit back on your legs, keeping your hands stretched out in front of you and lower your head. Hold for ten.
15. Keeping your hands in place, scoop through the arms so that the waist is on the floor and raise your head to the ceiling. Repeat 13 and 14.
16. Sit on the floor with your legs in front of you and slowly bring your feet to your waist making your knees butterfly out and slowly stretch your torso forward for a count of ten and repeat.
17. Extend your right foot forward and touch your toes for a count of ten and repeat.
18. Bring your right foot back and extend your left foot forward and touch your toes for a count of ten and repeat.
19. Extend both legs forward and touch your toes for two counts of ten.
20. Roll onto your back and extend your arms above your head parallel to the floor and stretch for a count of ten.
21. Bring your right knee to your chest and hold with your hands for a count of ten.
22. Lower your right and bring your left knee to your chest and hold for a count of ten and then lower.
23. Bring both knees to your chest and hold with your hands for a count of ten and as you lower your knees stretch your arms parallel to the floor and take a ten count stretch.
24. Roll to your side and get in a fetal position and then onto your knees and stand up.
25. Extend your arms to the ceiling and take one last stretch.

Meditation is a great way to become more relaxed and neutral. It helps to calm the body as well as the mind. When you meditate, you focus your attention and eliminate the stream of jumbled thoughts that may be crowding your mind and causing stress. It helps to increase yourself awareness and helps you to live in the present moment. This process results in enhanced physical and emotional well-being.

There are many types of meditation which include: Yoga, Tai chi, mindfulness, mantra, transcendental and guided. The following Ground and Centering is a first step to going into a deep mindful meditation. This can be used at the beginning of the actor's warm-up.

> Meditation is not a way of making your mind quiet. It's a way of entering into the quiet that's already there – buried under the 50,000 thoughts the average person thinks every day. Deepak Chopra

Ground and Centering

Focus on each task and don't let your mind wander. Lie down on your back and relax. Let your body flatten and spread across the floor like a pancake. Focus on your circle of breath. Think of nothing else but your breath. It works in a circular motion – going in and around and out – in and around and out. Focus on the circle of breath till you become one with it. Next think of your body as an empty shell. It has nothing inside it. On each breath think of a different worry or problem or anxiety in your life and slowly fill up your empty shell with each problem. Think of a problem and put in your toes. On the next breath, think of a new problem and put it in your feet and on the next breath put that problem in your ankles and so on until you have filled up all of

your body with those problems. Once you have a completely full shell you will need to empty it and get rid of all these problems and worries. Empty out the shell by taking a deep breath and blowing out the head and then another deep breath and blow out or empty the neck and shoulders, then the arms and so on until you have blown out and emptied each party of your body. Next you want to fill up the shell with positivity and purity. Imagine tiny little p's filling up the shell by whispering or saying in your head ppppppppppppppppppp until you have a completely full shell again. Just like before, you then want to empty out the shell by taking big breaths and blowing out the shell or body piece by piece. Once you have a completely empty shell imagine soft, silky ropes being tied around your ankle. They won't pull your ankles but are just tied snuggly. Once they are tied see these two rope get longer and go through the floor and into the ground. Imagine them going deeper and deeper into the ground until they finally hit the core of the earth. Once it hits the core of the earth, the positive energy from the core starts to shoot up the ropes. Imagine it coming up and up and up the ropes until the positive energy comes up into your ankle. Bring it up through your legs and into your stomach. Start to mix the positive energy from the core of the earth in your stomach. As you are doing that, imagine the top of your head opening up. All of the positive energy from the universe starts to come down through your head, down your neck and chest and into your stomach. Mix the positive energy from the universe with the positive energy from the core of the earth. Mix them until they become a milky white substance. Then let the positive

milky white substance fill up the shell or body piece by piece starting with the toes on up until it comes out the top of your head and sprinkles all around you like a mist. You can then say to yourself that you are grounded and centered, ready to take on the world with a relaxed positive attitude.

Once the actor's body is in a neutral state, it is time to take on the body of the character. There are five elements that influence the formation of the physical body and are important given circumstances to look at in order to develop each character individually.

1. Heredity

This contains all the factors that are in our DNA and that we are born with. In Henrik Ibsen's Hedda Gabler, Hedda is written with brown hair. She feels it is ugly and that probably affects the way that she deals with it. Sometimes it is not written in the script and the actor can make up the hereditary detail. The father and three sons in Eugene O'Neill's Desire Under the Elms may all have an hereditary sway back and therefore all stand in a similar manner. It is not written anywhere in the script, but can be a great way to connect a family physically.

2. Physical Activity

This includes all the physical activities and experiences we have throughout our lives. Walking, running, jumping, lifting, sleeping, bike riding, giving birth, guitar playing, sewing and riding a horse are all example of physical activity that shape our bodies. The father and sons in O'Neill's Desire Under the Elms

are all farmers who on a daily basis perform hard physical labor and this should be reflected in their bodies.

3. Emotional and Psychological Activity

This is how all of our emotions, attitudes and experiences are reflected in our physical state. This is how we truly see the emotional and physical sides connect. Laura in Tennessee Williams' Glass Menagerie is emotionally beat down from her mother and has a low self-esteem. Her shoulders would then be rounded forward and her chest caved in to show her insecurity and sadness. Remember our bodies reflect our emotions.

4. Nutrition

This is all the fuel, physically as well as psychologically, that the body digests in order to keep developing and growing. The character may have been living in the desert alone and their lack of social activity combined with their lack of healthy eating habits would be reflected in their body.

5. Environment

This includes all physical, social and psychological structures within which we live our lives. The character may be from a rural, poor area where he hardly has any social interaction and whose parents are constantly degrading him. The body of this character would be awkward and caved in at the chest; whereas a character from an urban area with lots of social interaction and whose parents are supportive and positive would hold his body more

upright and stick out his chest. Unlike hereditary factors, environmental factors can change.

Although these five elements are important to analyze separately, they all influence each other and together make up the complete physical body. After understanding these five elements, the actor then needs to start to take on the body of the character.

Center of Energy

The first part of the physical character to take on is the character's center of energy. Since the emotional and physical parts of us are connected, our bodies reflect our emotions. Emotions are held in different parts of our bodies. Our muscles remember emotions. Every time we feel anger, certain muscles tighten, our breathing increases and the palms of our hands can become sweaty.

The six centers of energy are where we hold that emotion in our bodies. These six centers are the head, shoulders, chest, stomach, pelvis and knees. The actor should start to play with these six centers first as they start to physically develop the character and the dialogue.

When they first start to play with each center, the actor should make sure to start in a neutral position. This can be achieved by putting your body flat against a wall and making sure it is straight up and down. Or, you can imagine your body is like a marionette with a string coming up through the middle of your torso and coming out your head. Play with the dialogue as you play with each center and see where the different centers work.

The Head – bring your head forward, leaving the shoulders back. Imagine the energy coming out of the head and pulling you forward. This might make you feel authoritative, superior, or intellectual.

The Shoulders – roll your shoulders slightly forward and leave your head back. Feel a heaviness on them. Imagine the energy coming out of the shoulders and pulling you forward. This might make you feel beaten down and insecure with low self-esteem.

The Chest – stick your chest out slightly, leaving the shoulders and head back. Imagine the energy coming out of your chest and pulling you forward. This might give you a feeling of power, confidence and control or it might make you feel defensive as well.

The Stomach – keep your body neutral but think of a weight in the middle of the torso. Do not stick your stomach out. Imagine the energy coming from the weight in your torso and pulling you forward. This might make you feel more neutral emotionally and stress free.

The Pelvis – bring your pelvis slightly forward. Imagine the energy coming out of your pelvis and pulling you forward. This might make you feel sexual or with a different type of confidence.

The Knees – slightly bend your knees and imagine the bottom half of your legs as being extremely heavy. Imagine the energy coming out of your knees and pulling you forward. This might make you feel tired, beat down and weary.

Although we use all of these at different times depending on our emotion and our objectives, there is usually one center of energy that we go to as our habitual center. The center of energy we feel most comfortable living in. This can be dictated by many different factors in our given circumstances.

Maybe the character has lower back problems so they put their energy in their chest to relieve the stress on that part of the back and then that center of energy becomes their habitual center. The character may be constantly put down and criticized by their parents therefore putting their energy in the shoulders and they get so use to it that it becomes the habitual center.

The next step in creating the character physically is to develop the relationship that the limbs have with the body. This can be done by first sitting in a chair in a neutral position. Make sure that you are sitting up straight with your legs shoulder-width apart and your hands in your lap. Next, take on your character's habitual center. Now take your feet and put them closer to each other. Maybe an inch or two apart. Get up, walk around the room and then come back and sit in the chair. Next try the opposite. Go back to the neutral position and move your feet further apart and get up and walk around the room and then come back to the chair. Then make the decision of which of these positions felt right for your character. Put your feet where they felt right, either in or out or center and then play with your arms in the same manner. Once with the arms an inch or two away from the torso and then

try it with the arms tight to the torso almost as if the elbows are connected to the torso. Then make the decision of which of those work for your character. The thing to remember is that all of these positions are in degrees and how far you go with them depends on the character and the form and style of the script.

A person's feet and the way they use them for support and balance are a great indicator of how grounded and stable that person is emotionally. The feet are our contact with reality. If they are imbalanced, it throws off the balance of the whole structure. Therefore, the feet are a reflection to our attitude to life.

Healthy Feet

Healthy, unblocked feet are platforms with three distinct points of contact and an average arch. The type of people with healthy feet are stable, grounded and balanced.

Clenched Feet

When a person clenches their feet, they curl their toes and the arch will clench in an attempt to hold on to the earth, much like a bird holds on to a branch. If a person does this chronically, the feet become rigid and tense. This tension is usually related to an unresolved emotional crisis that involved some kind of movement or running away. This type of person has an overdeveloped need to hold on and to try and keep control.

Heels

By putting all of your weight on your heels, you can be easily pushed over. This will develop into a need for determination and control but is grounded in deep feelings of fear and instability. Spontaneous situations will cause this type of person to have a hard time relaxing and feeling comfortable.

Toes

When we see a person with all their weight on the toes or balls of their feet, they seem to look like they could float off the ground. These people usually have a hard time making contact psychologically with the world. On one hand, they may seem like dreamers with great imaginations and on the other hand, they are lost and off balance.

Keeping in mind the given circumstances of your character, get up and take on what you have discovered so far with the character physically. Now play with these four different ways to put weight on your feet. In addition, play with the placement of the feet. Try them straight forward, pointed in (pigeon toed) or pointed out (duck toed). This will give a great foundation to develop your character physically,

Animal Persona

Animal Persona can be another great tool that the actor can use to develop the character physically. By playing with their body as an animal that physically embodies the character's personality, the actor may find various physical characteristics and intricacies. Choose an animal that has a similar personality to your character. Start to move around the room as that animal. Pay attention to how it moves and relates to the world around it. Maybe your character is like a chicken. You might discover a nervous energy to your character that has a center of energy in your head that jerks at times. Your character may be like a stallion and you will discover that your character has a center of energy in the chest and holds their head up and moves with a grace and poise.

An actor playing Menelaus in my production of Troy Woman decided his character was like a big gorilla coming in and taking all the women away. For a couple of rehearsals he took on the gorilla's physicality and as he played with it he found his character was bow legged and walked with a sway. His arms and hands guided his direction and related to the world in a unique way. Make sure that you go all out and play with the animal persona and then you can pull back and make it as subtle as you want.

Self-Adapter

Many times our emotions manifest themselves into a physical activity. We learn these behaviors in order to handle certain emotions. Some of these are voluntary and when the emotion is extremely strong

it may be involuntary. This physical activity is called a self-adapter. I have seen people that are nervous bite their fingernails or bite the back of their hand. I had a friend that would stroke her hair when she needed comfort and another friend would stroke their nose when they felt unsure of the future. These are all examples of self-adapters that are more voluntary and are easier to control. Sometimes the emotion may be extremely strong like intense fear and this may manifest in a shaking hand or a strange tick in the body. I knew a woman that was traumatized by her parent's divorce and whenever she was feeling abandoned her hand would shake uncontrollably. Self-adapters can be a great tool to bring in more subtleties physically to your character. Remember they are tied to certain emotions and are only performed when the character is feeling that emotion.

Clothing

The clothing we wear has a direct effect on our physicality. It is extremely important to find out from the director or costume designer what your character will be wearing and then get rehearsal clothing to wear throughout the rehearsals, especially the shoes. We hold our bodies differently in flip flops compared to cowboy boots. Women sit differently in a dress compared to a pair of pants. Don't wait until dress rehearsals to play with the clothing. Many times you won't find your character until you get in their clothing. When I played Major Metcalf in the Mousetrap by Agatha Christie, I was having trouble finding the character until one night when I was working at home I put on clothing

that was close to what he would wear as well as his makeup and when I looked in the mirror, my body completely changed into the character's and his voice came out. It was a transforming experience for me as an actor

Tempo

Tempo and rhythm dictates the character's movement, emotions and intellectual activity. Tempo is more the pace or speed of something and rhythm is a regularly repeated pattern. The five elements discussed earlier in this chapter will help to define the character's tempo and rhythm as well as the language the character speaks.

The actor should first find their character's main tempo. This tempo is the one that they work at in general. A kind of safety tempo that they always go back to and embody. Walk around the room taking on the characters physicality that you discovered from the above tools. As you walk, slowly get faster until you are almost running and then slowly get slower until you are barely moving. Decide in that range of tempos where your character's main tempo would live. Once you have found your character's main tempo, you can find their secondary tempos. One is a tempo that is a little faster than the main tempo and the other is a tempo that is a little slower than their main tempo.

Now use these three tempos to play with the duration at which they use each tempo. Again walk around the room as your character and play with how long you stay within each tempo. Think of your scene

and what may cause you to change tempos and how that dictates how long you stay in that tempo.

Many times another character's tempo can influence our own character's tempo and we will mimic theirs. Start walking around the room with your character's main tempo and then mimic or copy another character's tempo. Remember only to mimic their tempo, not the way they are walking. Do this several times, going back to your own tempo and rhythm each time.

Our environment also has an effect on our tempo and rhythms. Walk around the room starting with your main tempo and every time you get near a piece of furniture or another person have it change your tempo and/or direction. This will help you start to play off your surroundings and get you in sync with the world around you.

Be careful of getting stuck in one tempo. This can become monotonous and bore an audience. A simple activity can have many tempos within it. Pick an activity that your character performs in the play that has a beginning, middle and end. The activity could be as simple as looking for a resume, finding it and then giving it to the other character. First perform the activity with one tempo and then try it performing the first part fast and the second part slow. Then try it the opposite of that. Also play with it slow, fast, slow or fast, slow, fast. It might add some great humor to the activity if the character is using a fast tempo to find their resume and then once the find it, they hand it slowly to the other character. Remember each character has their own tempo and rhythm

and by playing with the duration, mimicking and environmental factors, you can find the nuances of the character's inner clock.

When you are first playing with and taking on the character's physicality, it can feel extremely strange and foreign. It needs to become second nature. That is why it is important to take on the character's physical body every time you rehearse. Doing activities around your house as your character can help. Cleaning your kitchen, doing laundry or even going grocery shopping can help you to relax into the body of the character. Eventually, it will become part of your muscle memory and then you can tap into your instincts and intuitions physically as the character.

We are limited as actors and the roles that we can play by the body that we are born with so it is extremely important for the actor to be physically versatile. That means that the actor needs to know their body and how to use it. There are many physical activities that can help with this; dancing, yoga, tia chi, boxing, aerobics, or any kind of movement class. All of these activities will help the actor to have a healthy self-image which will free them physically.

Emotional Memory

Let us now discuss the other part of the basic self which is emotional memory. What is an emotion? An emotion is a state of mind or feeling triggered by the process of an action (an objective) confronting the outside world (an

> Your emotions are the slaves to your thoughts and you are the slave to your emotions.
> Elizabeth Gilbert

obstacle) creating a thought that taps into a memory. To understand this long definition and how it can be utilized to create the emotional side of the human condition, it will help to break it down and discuss the different parts.

A state of mind or feeling is usually labeled by the words sad, angry, happy etc. The problem is that these words are too general in their meaning. Emotions are usually a combination of these labels. When a student was asked what she felt after her mother had died of a long, drawn out fight with cancer, she had a hard time defining the emotion. She was feeling sad layered with both happiness and guilt because she was relieved. No one theorist can agree on how many basic emotions there are. Some say ten, others say five and one even says there are only two, pleasure and pain. This is why it is difficult or almost impossible for an actor to play an emotion and make it authentic. The actor will end up indicating the emotion and playing a generalization. It is what we label as bad acting.

To make sure you are not indicating an emotion, you must remember that an emotion is triggered. When the lights go out and you hear a loud noise, you then will feel fear. You don't feel fear and then the lights go out. Therefore to have an authentic emotion, it must be a reaction to an action we are taking and the obstacles in the action's way.

This ties back to the beat work on the intellectual side of the human condition. It is the character's want or objective confronting that obstacle that creates the emotion. I want to control my child despite the child wanting his freedom which creates an emotion of

frustration and anger. This is still too much of a shortcut to get to the emotion.

This objective confronting the obstacle creates a thought. Our thoughts, or the voice inside our head, are triggering us all the time. That is why it is extremely important for the actor to click over and be thinking as the character on stage. This can only be done when you have developed the given circumstances and have a deep understanding of the character's biography. The more specific you are with your given circumstances, the easier it will be to think as the character. When on stage as the character, that voice inside your head has to be thinking the character's thoughts. You can't be on stage and in character but thinking *"So I have to go do laundry after the show"*. No, you have to be thinking as that character and listening to the other characters on stage. An exercise that can help you click over to thinking as the character is this stream of conscience exercise.

Stream of Conscious Exercise:

Walk around the room, tapping into the voice inside your head. After a few minutes, speak out loud in that voice. Then after a few minutes pull it back inside your head. Do this several times. Now start thinking with your character's voice inside your head. After a few minutes, speak it out loud. Then like before pull it back inside. Do this several times.

This can help you slowly switch over to thinking as the character. The thought that is triggered taps into a memory which finally creates the emotion. The thoughts then tap into memories. So to shorten

the definition, emotions are triggered by memories. They are energy patterns set off by memory patterns. People don't go around full of sadness but people do dwell on memories that trigger them to feel sad. As an actor it is of vital importance to do visualizations and create vivid memories for the character. This work will have an effect on the subconscious level which does not differentiate between real memories and memories that are created from reading a book or fantasizing. As a character, you will be tapping into given circumstances that utilize your own memory patterns. This is what makes each actor unique in the role. The goal is to be emotionally authentic on stage.

Being emotionally authentic is not easy. We live in a culture that tells us not to feel or if we do feel we need to do it in private. As actors it is your job to show emotions. Many times actors try to force an emotion. All this does is create more tension around the memory and blocks the emotion more. What you must do is let go and allow the emotion to be stimulated. It is important in our personal life to let ourselves feel more. This will then let our characters on stage be more emotional as well. This could be done by employing 2 steps. First, by acknowledging your emotions (I feel angry). Secondly, by accepting these emotions (it's okay that I'm angry) and letting yourself feel the emotion. Many people are scared because they are afraid that they won't stop feeling the emotion. Let yourself feel the emotion and the opposite happens and eventually the emotion dissipates. Embrace the memory that triggers the emotion and then let the memory go and the

emotion will dissipate. This will also make you a healthier person because emotions are part of our human condition. To block those emotions and not deal with them can cause more tension in our bodies and can make us ill. Anger, guilt, and resentment if not dealt with can create physical illnesses. Remember it is healthy to feel.

Another exercise you can you use to open yourself up to emotions is the primal moan exercise. This will help you to open up to varied emotions. This may feel silly at first but only works if you fully commit to the exercise.

Primal Moan exercise

Lay on the floor in a fetal position. Let your stream of consciousness go. Start moaning. Make sure the moans come from deep within your body. Keep moaning until it brings up a strong emotion. This may take 3 to 5 minutes. Once the emotion comes up, embrace the emotion. Let yourself feel it. After you have experienced the emotion, try to go back and remember what thoughts and memories helped trigger it. These can be used as triggers to open you up to emotions in the future.

Since actors are portraying characters at extreme emotional moments in their lives, you will need to go to emotional places you may not have allowed yourself to feel in quite a while. Your body doesn't remember the feeling. I had to play a character once where they had to feel extreme rage as they tore a room apart and then deep sadness and sorrow over a picture that he found of him and his daughter when she was young. I hadn't felt that emotion in quite a while. I was blocked and couldn't get there emotionally. My body didn't allow me to open

up. It didn't remember. I used the next two exercises to open myself up to that emotion. The first exercise is creating a hypothetical experience using your own life experience.

Don't Go Exercise

Take someone from your life that you always wish you would have said something to that has a strong emotion tied to that message. For example, a boss that you wish you would have told off or your grandmother who you wished you would have told that you loved her before her death. Now stand up straight with your arms at your side and close your eyes. Take a deep breath in and relax. Start to see the other person standing in front of you – what clothes they have on, what their hair and face look like – get a clear picture of them in your mind. Now in your mind tell them what you always wanted to tell them. Then open your eyes and see them standing in front of you and they start to turn and walk away. Take all the emotion and what you wanted to tell them and transfer it into the words *don't go*. Spectators of the exercise won't know who you are talking to or what you told them. They will only see the emotion coming out in the words *don't go*.

Your life and memories are at your disposal to use as an actor. You may not have experienced what the character is going through but you can use a hypothetical experience to help you open up to it.

> Memories establish the past.
> Senses perceive the present.
> Imagination shapes the future.
> Toba Beta

If you do have an experience to draw from, the emotional memory exercise is the tool you should use to open yourself up to emotions you have not felt in a while. The more specific you can get with the details, the more the exercise will help you. This exercise works best with a partner or in front of a class or group of people.

Emotional Memory Exercise

Select a memory from an experience that has a strong emotion tied to it. Then tell this experience and memory to your partner or the group. Try to be as specific as you can with the details because those thoughts and memories are what will trigger the emotion. Once you are done and you have felt the emotion again, go back and remember what images and thoughts helped to trigger that emotion. These can serve you as a trigger to open yourself up to these emotions in the future.

For example, an actress told about a memory of when she found out her grandmother had died. She was 12 years old playing a game in her living room. She was extremely specific about remembering the room and the game. She even remembered what she was wearing. She heard her mother drive up in the driveway, heard her come in the kitchen door, walk through the house and come into the living room, where she stood in the doorway wearing a brown coat. Her mother then proceeded to tell her that her grandmother had passed. At one point when she was telling the story she started to cry. After the exercise, I asked her what image or thought made her cry. She said it was that brown coat that her mother wore. That brown coat always reminded her

of that moment when her mother had told her that her grandmother was gone. That brown coat is her trigger she can use in the future.

The last two exercises are used to open yourself up to emotions and should be done away from the rehearsal process. Use them to open yourself up to the emotions, but when you're in the moment as the character you need to be thinking as the character and not about your own memory or experience. If you did think about your own life, it would pull you in and out of the character's journey. To be emotionally authentic, you need to live in the mind of the character as much as possible.

Another tool you can use to open up an emotionally and relate to a character is personalization. Personalization is taking the experience from your own life and relating it to a character, a scene or even a phrase so that you can emotionally connect to them. Try to find a similar experience to the character's experience. I once played James Wicker in Terrence McNally's It's Only a Play. The character learns that the sitcom he starred in is cancelled. I used a personal memory of losing my job with the university I worked for when it went bankrupt and I got laid off. This helped me relate to what James was going through and his coping process.

Sometimes you may not have an exact experience to draw upon. You can then use a hypothetical experience based from your life. In Sam Shepard's True West, Lee, an indigent, is manipulating his brother Austin, who is a screenwriter, into helping him write a film. Lee knows

hardly anything about the writing process. To relate to Austin and personalize his struggle, I would use a hypothetical from my own life. It would be like one of my brothers who are farmers trying to tell me how to teach an acting class.

Personalization makes you have a stake in your work. It gets you to work from the heart. Your work will become better and richer when you personalize. You will find yourself drawn to characters and scripts that you can relate to and you'll have a need to create for an audience so that they can see themselves and relate to it as well.

> There is no way to understand the world without first detecting it through the radar-net of our senses.
> Diane Ackerman

A part of the physical side that affects us emotionally is our senses. Our senses are triggering memories in us all the time. I can taste my grandma's chicken noodles just by thinking about them and it makes me feel safe and content. The memory of smelling a chicken coop makes me sick to my stomach and angry because as a kid I had to collect eggs and I always hated it because of the smell. Tapping into your sense memory also helps to create the environment for the audience. Sense Memory is the recreating of an activity by living through your senses. Your character might be in a scene where they are on a terrace overlooking the ocean, drinking a glass of wine. In reality, you are probably looking directly over the audience and drinking cranberry juice. Use your visual sense memory to see the ocean and the waves hitting the beach. Use your taste sense memory of drinking wine and

how it goes down. If you see the ocean, the audience will see it and if you taste the wine the audience will believe that the cranberry juice is wine. This can also be done with touch, smell and aural senses as well.

Be more aware of how your five senses trigger you. This will help you tap into your sense memory so you can recreate them triggered by the five senses on stage.

Sense Memory Exercise

1. Pick an activity and perform it, being aware of the senses involved. For example: perform drinking a cup of hot chocolate. Be aware of the hot mug as you touch it, smell the chocolate, taste the chocolate, feel the hot liquid on the rim of the cup, set it down and feel the warmth of the cup still on your skin. All of the time, be aware of how each sense triggers you emotionally.

2. Now, without using the object, recreate the activity using your sense memory. Be specific in each moment of the activity. If you feel that you lost the sense memory and did not recreate specifically, go back to step one and experience the activity again using the object. Then try step 2 again. If I'm drinking the hot chocolate and within the activity did not feel the hot chocolate on my lips or taste the chocolate, I would go back and experience drinking the real thing again. Again specificity is the key. The more specific you are, the easier it'll be for you to recreate the sense memory and the more you will be triggered emotionally. Here are just a few

examples of activities you can practice your sense memory with:

Brushing your teeth

Shaving

Drinking different types of liquids

Standing in the sunshine

Standing in a cold winter wind

Cleaning a dirty sink

Picking up dog droppings

Picking a bouquet of flowers

Listening to different types of music

Petting an animal

Not only is it important to refine your sense memory skills in order to trigger you emotionally, but it is also helps to create the environment for the audience. When I directed Desire Under the Elms by Eugene O'Neill, the character of Eben had to walk through the house and go outside where he ends up having a fight with his stepmother. The actor asked how hot I thought the temperature was in the scene. O'Neill had written that it was a hot, late August afternoon. So I figured it was about 82 degrees. The actor said ok and that he thought that the house is probably cooler because it was made of stone and was shaded by trees. The next time he performed the scene, he walked to the house and when he opened the door you saw the heat hit him and how it affected him emotionally. He became more irritated because of the heat and this added

to the conflict he was having with his mother. This is the type of specificity that you need to incorporate into your work. This sense memory could have triggered a memory for the actor of when he had to go somewhere important and he had to deal with the heat on his way there, which made him irritated and frustrated. He worried that he would look messy. This sense memory helped the actor to personalize the experience and better connect to the character. Use the following sense memory personalization exercise to better connect with the senses of your character.

Sense Memory and Personalization Exercise

Visual – Two students should face each other. One student should describe the other students face. Then have a part of that students face remind them of someone they know and have them tell about that person. Then switch. Afterwards have the students close their eyes and think about the person that they were reminded of and see how it makes them feel.

Aural - Two students should face each other. One of them tells what they did the night before as the other student listens to the qualities of the speaker's voice. After a few minutes have the listener describe the speaker's voice. Then have their voice remind them of someone they know and tell the speaker about this person. Next, have the students close their eyes and think about the person that they were reminded of and see how it makes them feel.

Touch – Each student should make their way around the room with their eyes closed until they find a surface or object to touch. With their sense of touch have them discover this surface and then have it remind them of a surface from their past and see how it makes them feel when they remember this.

Smell – Each student should be given something to smell and have it remind them of a smell from the past and see how that makes them feel.

Taste – Each student should be given something to taste and have it remind them of a taste from their past and see how that makes them feel.

> All we have to believe is our senses: the tools we have to perceive the world, ourselves, our touch, our memory.
> Neil Gaiman

The basic self is all based in the subconscious. You can use all of the tools in this chapter so that you can tap into that subconscious and act truly as the character. The subconscious helps you to trust in and use your instincts and intuitions. No matter what style you are performing in, they all start with the truth of the emotion. This means the physical and emotional sides working together. Emotion without technique is passable, but technique without emotion is embarrassing. You need to be emotionally authentic in every moment of the character to even begin to walk the razor's edge.

Chapter 5

The Higher Self

The higher self or superconscious is the spiritual side of the human condition. I have heard it called the soul. Just like defining the soul, the spiritual side is a little bit more abstract to understand. It is more of a spiritual essence that makes clear our physical, emotional and intellectual experience. Its primary motivation is to get the physical, emotional and intellectual sides of the human condition to work in harmony. Think of it as a journey inward to get to know and reveal yourself. The better you know yourself, the better actor you will be.

When the other three sides are not working in harmony, you need to look at yourself and try to define what is blocking it.

I was working with an actress who would let herself

> Learning is the beginning of wealth. Learning is the beginning of health.
> Learning is the beginning of spirituality. Searching and learning is where the miracle power all begins.
> Jim Rohn

get angry when she was performing her monologue. Something in her was keeping her from opening up. We started to talk about how she handles anger and her personal life. She said that she would just tuck it away and not let herself go to that emotion. I asked her how her family handles anger. Many times we learn how to handle emotions from our parents and our siblings. She said she had been raised with four sisters who all would show their anger. In fact, they would fight, punch, and

pull each other's hair. Suddenly, as she was talking, a light bulb went off in her head. She realized she didn't let herself get angry because she thought it was unladylike and crude. It scared her. I told her to go home and let herself become crude and ugly. Let herself feel the anger. It was okay to get angry and there was a true beauty in the truth of feeling that emotion. The next couple of weeks she opened herself up to the anger and was able to let the character feel the anger in the moment.

Another actress was playing a character that was begging her lover to stay and not break up with her. Every time she rehearsed the scene she wouldn't let herself become desperate and vulnerable. She was blocked to the extent that every time she tried to perform she would get a headache and feel sick. I got her to talk about her own personal past relationships. She came to realize that in the past she had a relationship that was exactly like the one in the scene. When her boyfriend was leaving her, she begged him to stay. After he left, she made a promise to herself to never be that desperate and vulnerable again. Now that she had identified the block, she let herself go back and remember those feelings. She then was able to perform the scene and go to the emotional places that the character had to experience.

The next example is of an actor I worked with that was having trouble physicalizing his character. He didn't allow himself to physically get out of the way that he held his body and couldn't take on the physicality of the character. He told me growing up that he had been made fun of physically. He was told that he was awkward and clumsy. He did not feel good about himself physically. I got him to take some

movement classes, as well as dance and martial arts classes. A year later I saw him perform and was amazed at how he was using his body. He was much freer to use the body because he felt more confident and had a higher body image.

The biggest obstacle you have in this work is yourself. Your fears, doubts and insecurities will sabotage and get in your way as an actor. That is why it is important to go on that journey inward and have a high self-esteem. Having a high self-esteem means to be able to look at your strengths and your weaknesses and be able to work on those weaknesses. All communication starts with yourself. That little voice inside your head is constantly speaking to you. If you're not able to communicate with yourself effectively, you won't be able to effectively communicate with others. Start being aware of that voice inside your head and get rid of the negative mantras that might hold you back. A thought is only a thought and a thought can be changed.

If a child has been told over and over again growing up that he is lazy, no good and will never make anything of himself, this may become a mantra that he keeps telling himself. This will become a self-fulfilling prophecy. The key is to turn the thought around and tell himself that he is vital and that he does achieve things in his life and can do anything he sets his mind to.

Working on your self-esteem is a daily job. Some days you wake up and feel like you could conquer the world – you are effectively communicating with yourself – other days you wake up and feel like

garbage and want to pull the sheets over your head- you are not effectively communicating with yourself. Turn these thoughts around and get out of bed!

Live in the present moment. So much of our lives we spend worrying about the future or obsessing about something that happened in our past. We can't control either of them. All of our power is in the moment right now. By living in the moment we can change the next moment. It is the healthiest place to live as a person and is vital for the actor.

Living in the Present Moment

Sit upright in a chair and put your hands comfortably in your lap. Close your eyes. Ask yourself, "What am I feeling right now?" Get past all the layers to what you are feeling right at this moment. Once you get to your feeling in that moment ask yourself, "Why am I feeling this?" Was it something that just happened or was it something a week ago or month ago that makes me feel this? Once you have gotten your answer take a deep breath and open your eyes. This should take about 5 minutes.

The more you can live in the present moment in your own life the easier it'll be for you to live in the present moment as the character.

All of the tools and exercises in this book are used to create the character and become part of your muscle memory so that you can truly live in the moment as the character, taking on his physical body, going after his wants and feeling his authentic emotions. The actor utilizes

these tools at home and then goes to rehearsal to try them. Each rehearsal the actor then refines them, finding the strongest choices. These choices need to become part of the actor's muscle memory so that they can live in the present moment reacting off the other actors. Remember that acting is reacting. Once the actor starts living the character, all he has to do when it comes to the performance is do a good warm up, prebeat and then go on the journey that he has created.

It is like hurdler practicing for the race. He breaks down how many steps between each hurdle. How to get each leg over the hurdle. He works on his thought process and emotional state as well. As he practices he lets those tools become part of his muscle memory so that he can live in the moment of the race. He learns it to forget it. Finally when the race comes, all he has to do is a good warm up, get in his stance and then run the race.

> You have to grow from the inside out. None can teach you, none can make you spiritual. There is no other teacher but your own soul.
> **Swami Vivekananda**

The actor, like the athlete, has to get the intellectual, emotional and physical sides to work in harmony to be successful. This means you must be healthy physically, emotionally, intellectually and spiritually. This is important because most of the characters an actor creates are extremely unhealthy and can damage the actor personally if they are not in harmony with the four parts of the human condition.

The seven shaman principles can help you to achieve that harmony. Serge Kahili King in his book Huna defines them in the following way.

1. The World Is Not What You Think It Is
The way that we perceive the world determines the way we experience it. Your mind influences your emotional and physical behavior. This behavior then, determines our personal experience in the world.

2. There Are No Limits
All limits are arbitrary and the Universe is infinite. Therefore, anything is possible if you can figure out how to do it. Everything you do influences the world around you.

3. Energy Flows Where the Attention Goes
Whatever you are focusing on will attract your physical and emotional energy. Learning to hold your focus at will and hold it on something for as long as you choose will lead to great success.

4. Now is the Moment of Power
By living in the present moment, we have the power to change the past and the future. Your past is memories in the present moment and you can change your thoughts about these memories which changes their effect on your life. Think of your future as a blank slate and you can give yourself permission to try anything.

5. To Love Is to Be Happy With
Love triggers action that changes or influences things and that is the essence of power. To love means to be connected and the depth and clarity of the love increases as fear, anger and doubt are removed. Happiness increases the stronger the connection is felt.

6. **All Power Comes from Within**

All of your power comes from your own mind, body and spirit and shapes your experiences.

7. **Effectiveness Is the Measure of Truth**

The means determines the end. Success must be measured by not only reaching the goal but also how we achieved the goal. The journey is just as important.

Become an actor who is a shaman warrior. Attack your work by making strong, bold choices. There's nothing worse than safe acting. Challenge yourself and take chances with your work. Nobody made a touchdown sitting on the sidelines.

Let this method of acting serve as a foundation to keep growing and developing as an actor. With it, you can start to get up and walk that razor's edge. Your work has to be exciting and dangerous enough that you may fall off, but if you're good enough to walk down the razor, it will cut you a little bit because you have to take on the characters life. This is just the beginning of an actor's journey of developing and growing. To become a great actor, creating well-rounded characters, the journey never ends.

Michael S. Pieper has been teaching acting since 1988. Michael joined the Chicago Second City Training Center in 1999 and is the Head of the Acting Program that he created with the late Martin de Maat. He received his Masters of Fine Arts in Directing from the United States International University of San Diego where he also was on the faculty for eight years. He was the Artistic Director of the North Coast Conservatory Theatre in San Diego, the Resident Director/Artistic Associate at the Trap Door Theatre and Artistic Director of the Boxer Rebellion Theatre, both in Chicago. Michael has directed over 94 productions and acted in over 40 productions.